HORNCHURCH

HISTORY TOUR

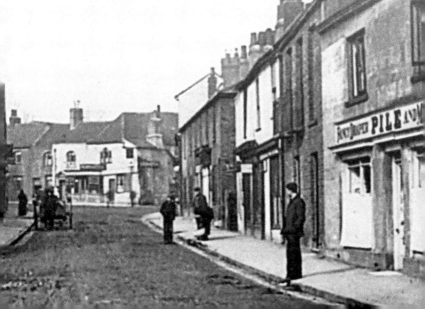

To Dave, Sheila and Tabitha Sealey

First published 2017

Amberley Publishing
The Hill, Stroud,
Gloucestershire, GL5 4EP
www.amberley-books.com

Copyright © Michael Foley, 2017
Map contains Ordnance Survey data
© Crown copyright and database right
[2017]

The right of Michael Foley to be
identified as the Author of this work
has been asserted in accordance with
the Copyrights, Designs and Patents
Act 1988.

British Library Cataloguing in
Publication Data.
A catalogue record for this book is
available from the British Library.

ISBN 978 1 4456 6892 5 (print)
ISBN 978 1 4456 6893 2 (ebook)

Origination by Amberley Publishing.
Printed in Great Britain.

INTRODUCTION

Hornchurch began life as a small village. While it may have existed in some way at the time of the Domesday Book, it wasn't mentioned in it. By the twelfth century, however, it did have a church built on the site of the present St Andrew's. This was known as the 'Horned Church' and it was where Hornchurch got its name.

By the eighteenth century Hornchurch was a quiet residential area, mainly confined to farming and a leather industry. It was within easy reach of London by coach or horse for the better-off residents who chose to live there.

By the nineteenth century Hornchurch had grown into a large village and, although the leather industry had declined by then, there was a brewery and a metal foundry there. There were also a number of brickworks around the village. It was the arrival of the railway that led to the greatest expansion as more homes sprang up around the station area.

The First World War led to an influx of servicemen as large houses such as Greytowers were turned into camps for the new recruits. Many units spent time in the town, perhaps the best remembered being the Sportsman's Battalion – a number of its members were well known from the field of sport or entertainment.

There was also an early airfield just outside the town on what was Sutton's Farm. The airfield gained noteriety when three of the pilots based there shot down German airships including Leefe Robinson, who became an overnight celebrity and a Victoria Cross recipient. Although the airfield closed after the war, it later reopened and played an important part in the Battle of Britain.

In 1965 Hornchurch became part of the London Borough of Havering but has still retained its own identity. Although there are not many very old buildings left in the town, it still provides interesting sites for a historical tour, especially for anyone with an interest in the First World War.

Michael Foley
www.michael-foley-history-writer.co.uk

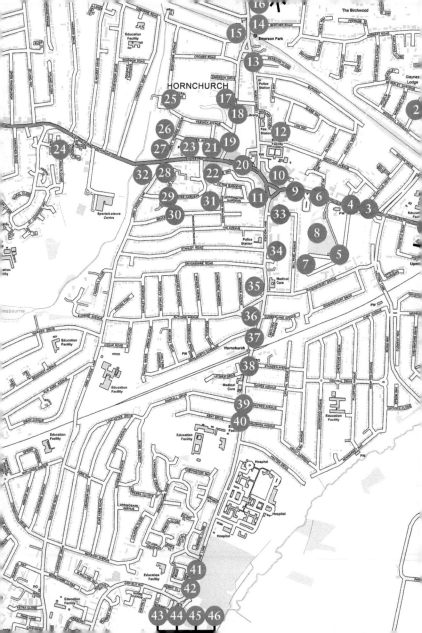

KEY

1. The Dip
2. Curtis Road
3. St Andrew's Church
4. Sportsman's Battalion Memorial
5. Graves of First World War New Zealander Soldiers
6. New Zealand Soldiers on Church Hill
7. The Mill and House
8. The Dell
9. The Village
10. High Road
11. The White Hart
12. North Street School
13. Emerson Park
14. Emerson Park Station
15. Butts Green Road
16. New Zealand Clubhouse
17. Langtons Gardens
18. Billet Lane
19. Fairkytes
20. High Road
21. High Road
22. High Road
23. The Tower Cinema
24. St Leonards Children's Home
25. Grey Towers House
26. Grey Towers Camp
27. Grey Towers Camp
28. The Camp Gates
29. The Founders of the Battalion
30. The Men of the Battalion
31. The Sportsman's Bid Farewell
32. Harrow Hill
33. The Queen's Theatre
34. Home Guard
35. Jack Cornwell
36. Sutton's Gardens
37. Hornchurch Station
38. Hornchurch Station
39. A Hornchurch Home
40. Station Lane
41. Sutton's Farm Airfield
42. Sutton's Farm Airfield
43. Sutton's Farm Airfield
44. RAF Hornchurch
45. RAF Hornchurch

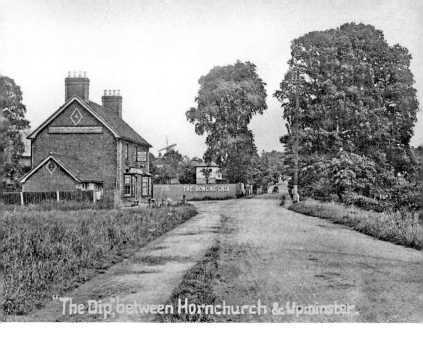

"The Dip" between Hornchurch & Upminster

1. THE DIP

The road between Upminster and Hornchurch was once no more than a farm track but is now a busy road. Hornchurch High Street ends at Hacton Lane crossroads and becomes Upminster Road until it crosses the River Ingrebourne, which has always been seen as the border between the two towns. The river is just beyond what was once the Bridge House pub, shown in the image. The pub is now called The Windmill and is just visible to the right of the building.

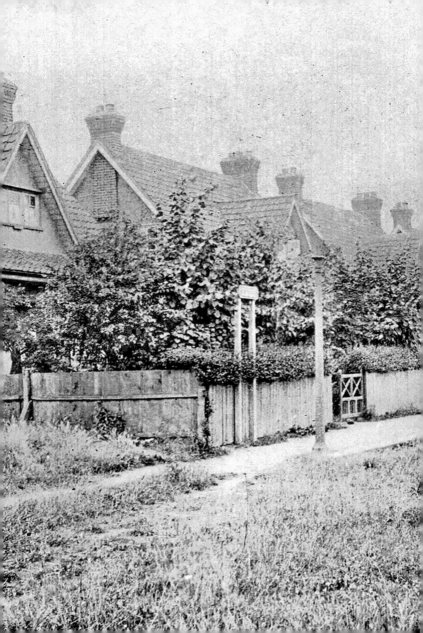

2. CURTIS ROAD

Curtis Road is situated in the affluent Emerson Park part of Hornchurch. Many of the houses are detached and it is one of the more affluent areas of the town.

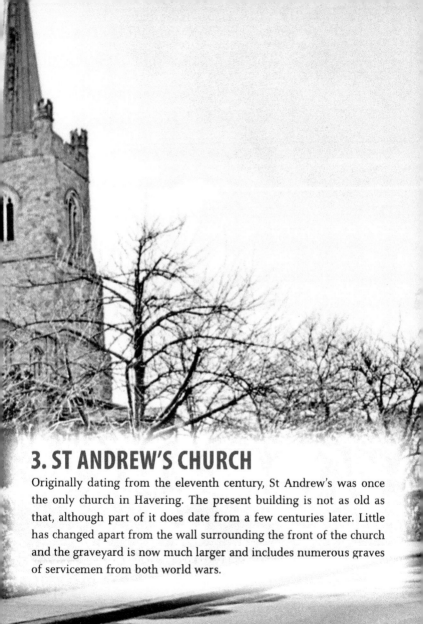

3. ST ANDREW'S CHURCH

Originally dating from the eleventh century, St Andrew's was once the only church in Havering. The present building is not as old as that, although part of it does date from a few centuries later. Little has changed apart from the wall surrounding the front of the church and the graveyard is now much larger and includes numerous graves of servicemen from both world wars.

4. SPORTSMAN'S BATTALION MEMORIAL

The memorial inside the church is dedicated to the Sportsman's Battalion, a special unit formed of men from the world of entertainment and sport. Due to their fitness they were allowed to join at a greater age than normal battalions. They were based in Hornchurch from their formation and were very popular with the locals.

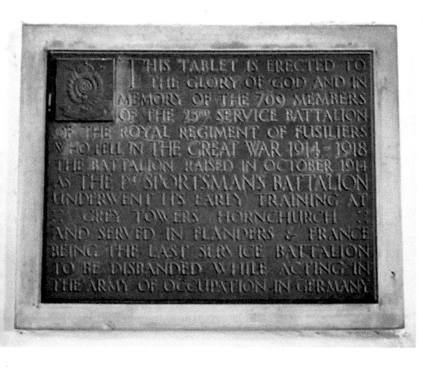

THIS TABLET IS ERECTED TO THE GLORY OF GOD AND IN MEMORY OF THE 700 MEMBERS OF THE 23RD SERVICE BATTALION OF THE ROYAL REGIMENT OF FUSILIERS WHO FELL IN THE GREAT WAR 1914-1918 THE BATTALION RAISED IN OCTOBER 1914 AS THE 1ST SPORTSMANS BATTALION UNDERWENT ITS EARLY TRAINING AT GREY TOWERS HORNCHURCH AND SERVED IN FLANDERS & FRANCE BEING THE LAST SERVICE BATTALION TO BE DISBANDED WHILE ACTING IN THE ARMY OF OCCUPATION IN GERMANY

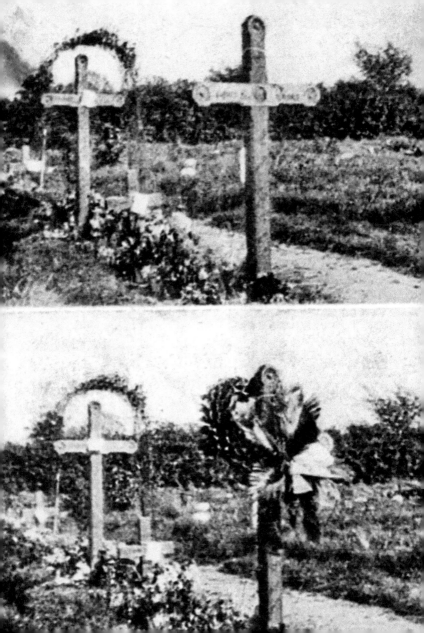

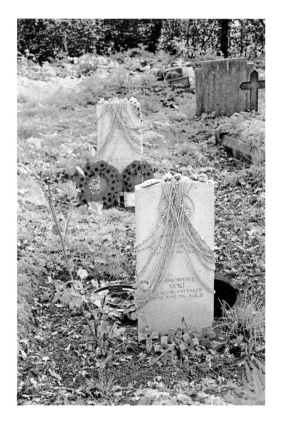

5. GRAVES OF FIRST WORLD WAR NEW ZEALANDER SOLDIERS

There are some unusual graves in the churchyard at Hornchurch. These are the graves of men who were part of the New Zealand forces based at Grey Towers when it became a hospital. They are also unusual in that the men buried in them were Maoris; every year they are visited by Maoris from New Zealand. They are also unusual in that two men are commemorated on each gravestone.

6. NEW ZEALAND SOLDIERS ON CHURCH HILL

Route marches by the soldiers based in Hornchurch during the First World War must have been a common site. This image of men from New Zealand shows them taking a rest, though they are not far from their camp at Grey Towers.

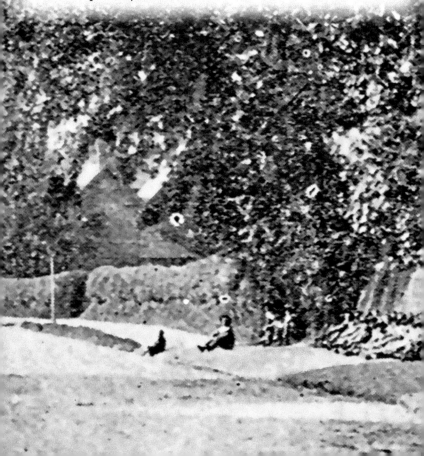

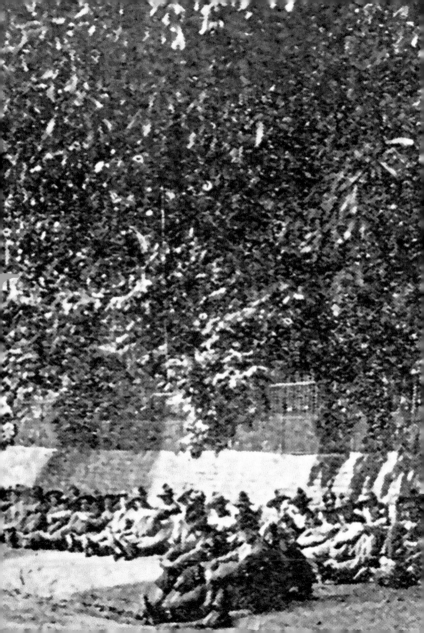

7. THE MILL AND HOUSE

Although the mill at Upminster is better known today, there was also a windmill in Hornchurch. The mill at Hornchurch dated back hundreds of years until it was closed just before the First World War – it burned down soon after. The mill-house still survives but is well screened from the road.

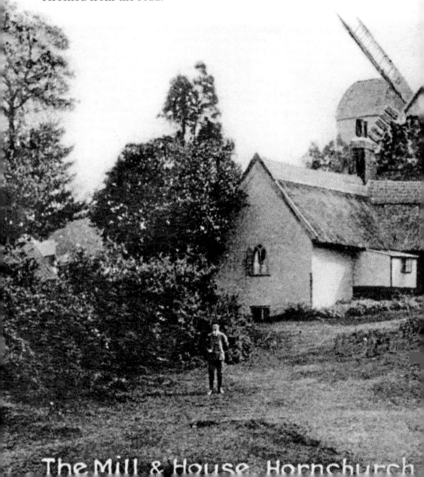

The Mill & House, Hornchurch

8. THE DELL

The Dell was supposedly an old quarry that became a sporting venue. The sport that took place there may not be recognised as such today as the main event seems to have been cockfighting. The area has now been overtaken by a large electricity-generating site and the surrounding area has been allowed to grow wild, mainly obscuring the view of the church.

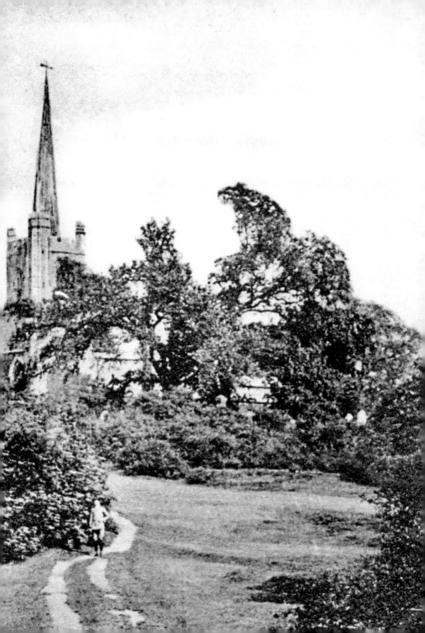

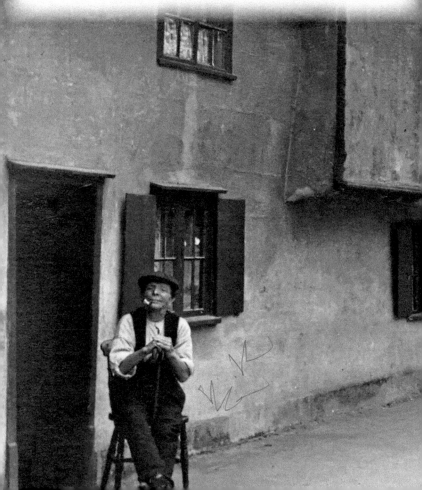

9. THE VILLAGE

An old view of what was Hornchurch village. The horse-drawn transport of the time can be seen. It wasn't unusual to see a resident taking his leisure outside his home. Very few old buildings have survived in the High Street; the inset shows one that has.

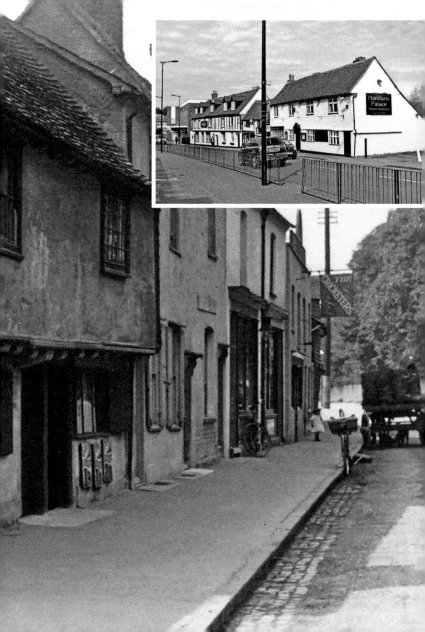

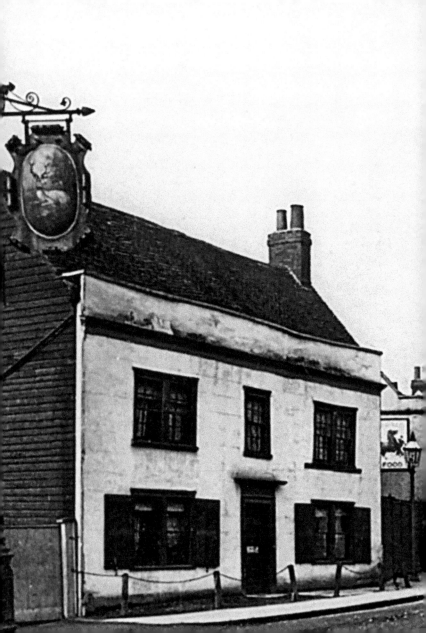

10. HIGH ROAD

This photograph of the High Street shows the old White Hart pub on the left and how narrow the road once was. Perhaps this is why so few of the buildings survived, along with the change to the traffic system that takes the road around the back of the building.

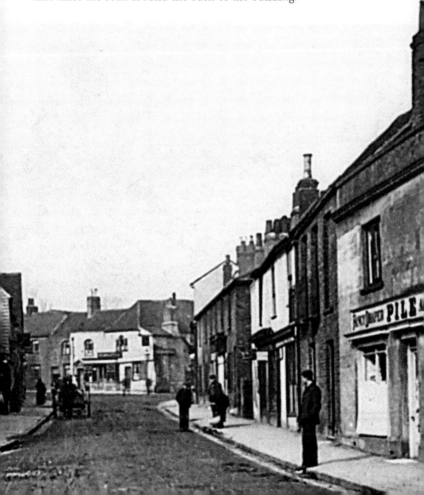

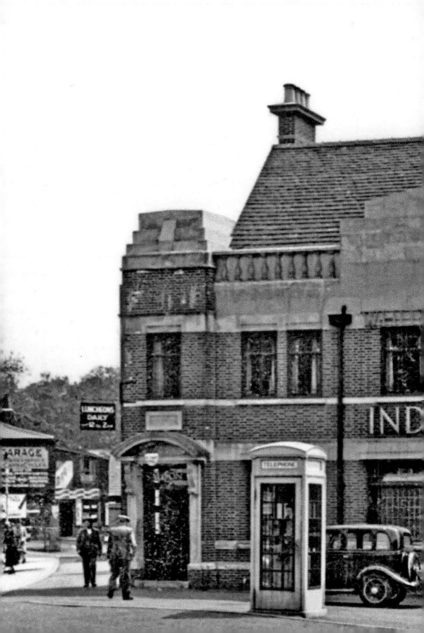

11. THE WHITE HART

The old pub dated from the nineteenth century but was rebuilt in the 1930s. After several renamings – such as the Madison Exchange, the Newt and Cucumber, and Lloyds – it has now become an Italian restaurant on an island surrounded by roads.

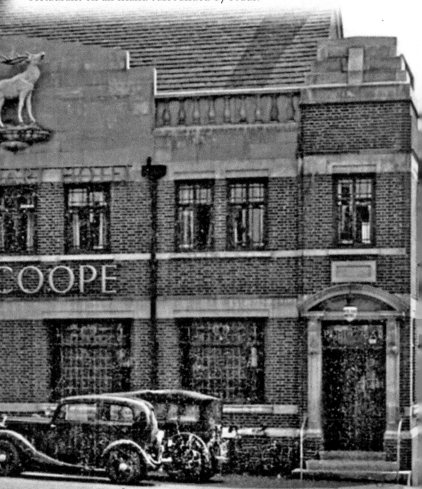

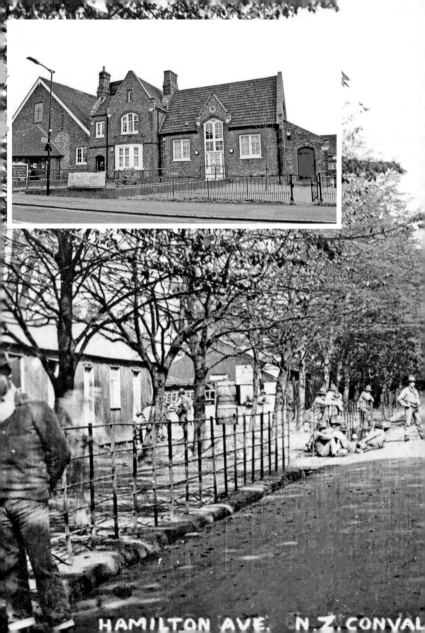

HAMILTON AVE. N.Z. CONVAL

12. NORTH STREET SCHOOL

The image shows men from the New Zealand forces who were based at the camp at Grey Towers after other units left. It shows one of the roadways inside the camp. The old school in North Street was one of the buildings that was used by the soldiers from Grey Towers as a clubhouse.

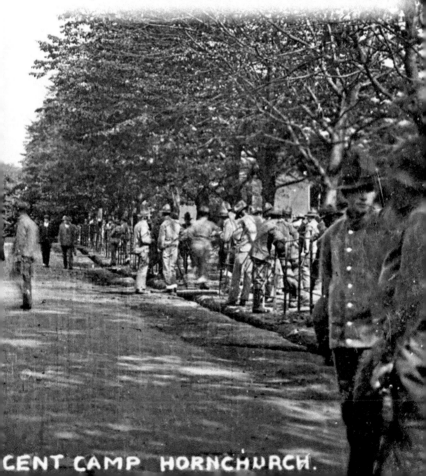

13. EMERSON PARK

The photograph was taken from outside the station and shows the Chequers public house. It is one of the few original buildings to survive and, like the old White Hart site, now finds itself marooned on an island surrounded by roads.

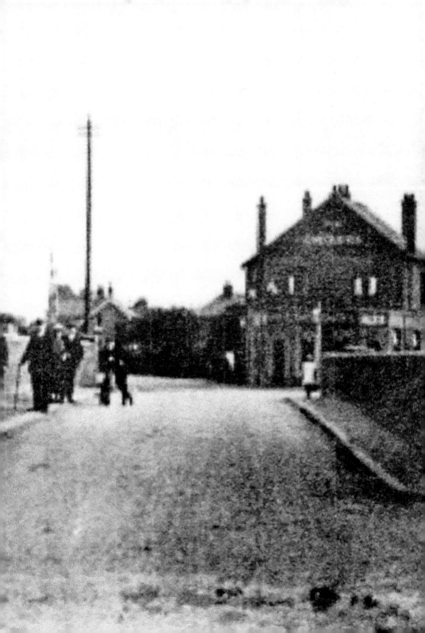

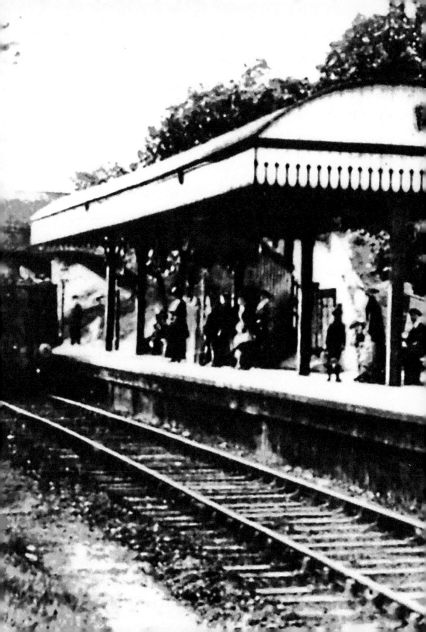

14. EMERSON PARK STATION

Emerson Park Halt caused uproar when it was built. It is the only station on the line between Romford and Upminster and opened in 1909. The line opened in 1893 and caused controversy between the Great Eastern Railway and the London, Tilbury & Southend Railway. They both wanted to run lines to Southend and the dispute led to refusal by the GER to let the LT&SR use Romford station, so they had to build their own next to it.

15. BUTTS GREEN ROAD

The buildings shown are shops that still stand by the railway line at Emerson Park. The buildings themselves have changed little, but the uses they have been put to have. As can be seen here, the shop on the right was once the estate dairy.

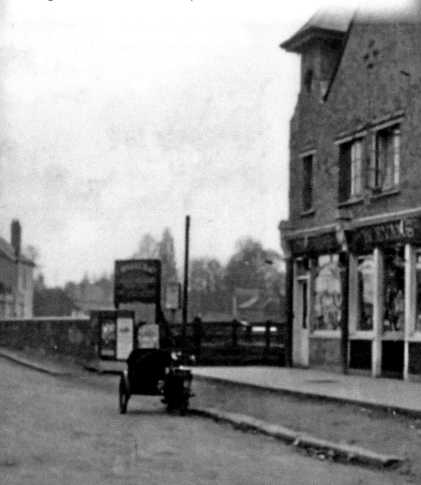

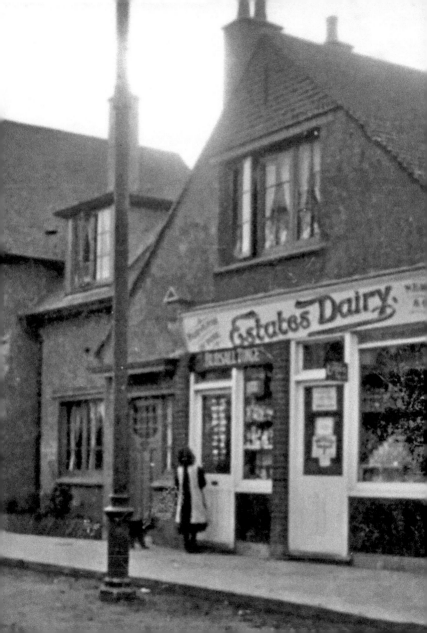

16. NEW ZEALAND CLUBHOUSE

The image shows men of the New Zealand Forces at Grey Towers gates. The men had a club built for them in Butts Green Road, which is still standing and known as Wykeham House, although it is now used as offices. A plaque commemorating its previous use by the New Zealand Forces was fitted to the wall a few years ago.

17. LANGTONS GARDENS

Langtons is now the Havering Registry Office and is also used as an arts centre. It was once part of a large estate that also included the land where Grey Towers House was built when the land was sold to Colonel Holmes. The gardens are often used as a background for wedding photographs.

Langtons Gardens, Hornchurch No

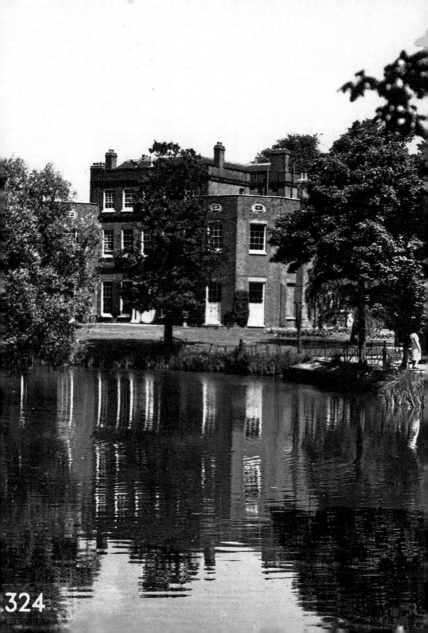

324

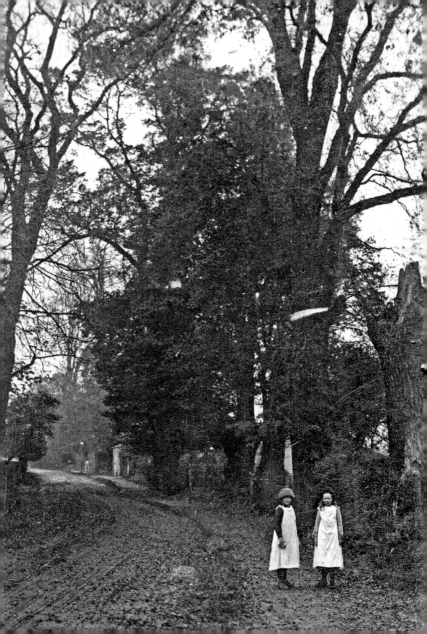

18. BILLET LANE

Billet Lane supposedly gets its name from an old inn, the Crooked Billet, which was open until the late nineteenth century. It was demolished sometime around the First World War. There was also an iron foundry in the lane opposite Fairkytes that was in operation during the nineteenth century.

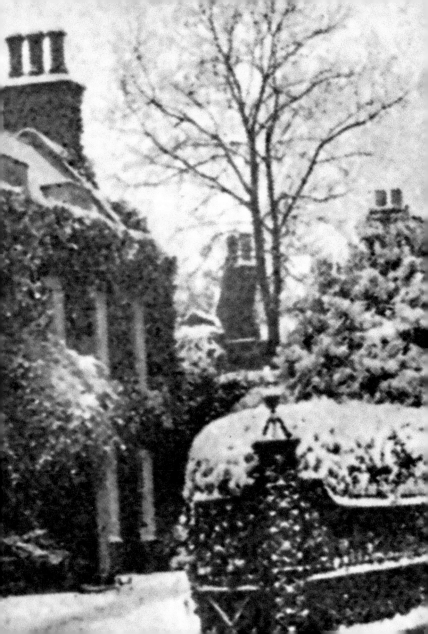

19. FAIRKYTES

Fairkytes was a private house and dates back to the mid-eighteenth century. It was added to in the nineteenth and was once the home of Joseph Fry, son of the prison reformer Elizabeth Fry. It was bought by the council in the 1950s and was used as a library, but became an arts centre in 1973.

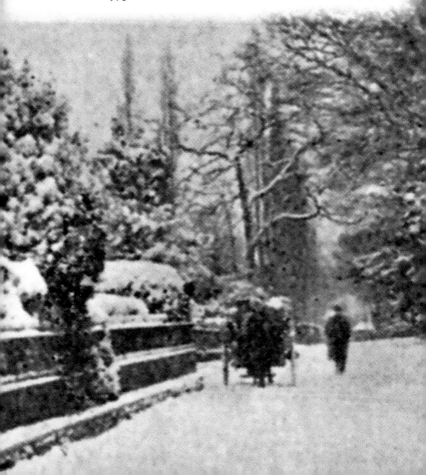

20. HIGH ROAD

The village of Hornchurch was much more rural in the past and transport was horse drawn rather than motorised. Horses would have been a much more common site in the streets than they are today, but this image shows early motorised vehicles using the streets.

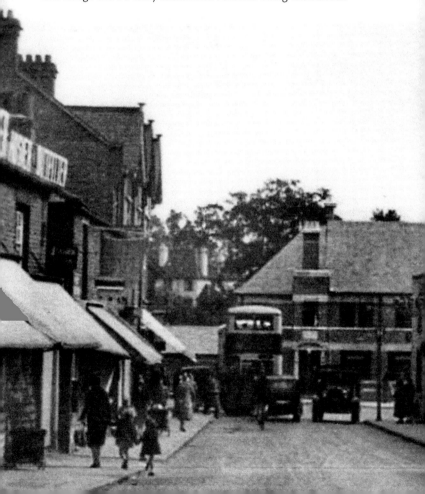

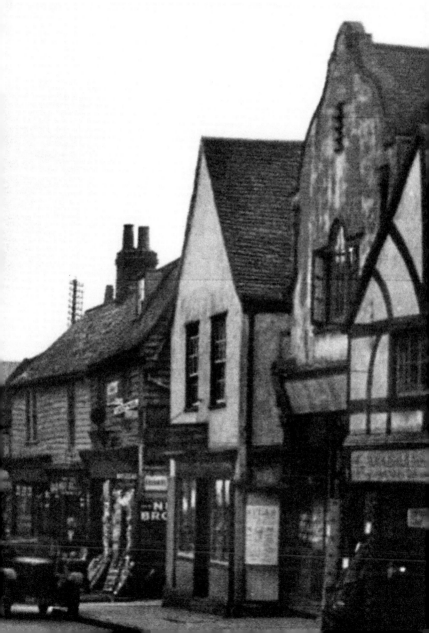

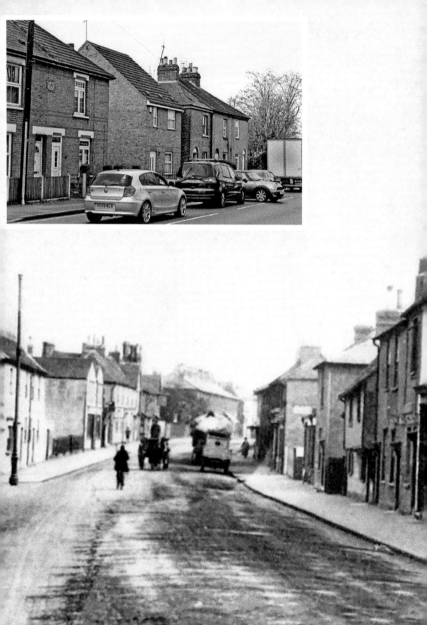

21. HIGH ROAD

Another view of the High Road showing the old Cricketers Inn. As with other old pubs in the town, the Cricketers was rebuilt. The photograph shows some of the early motorised transport in the town.

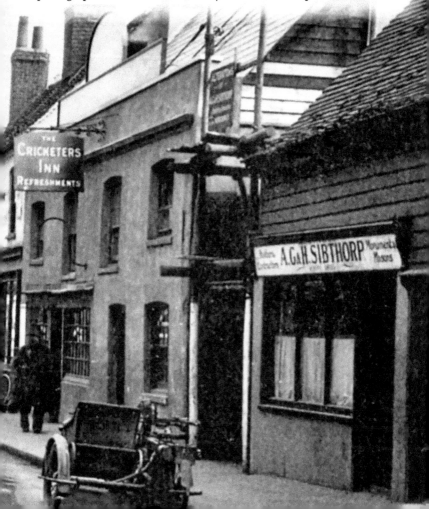

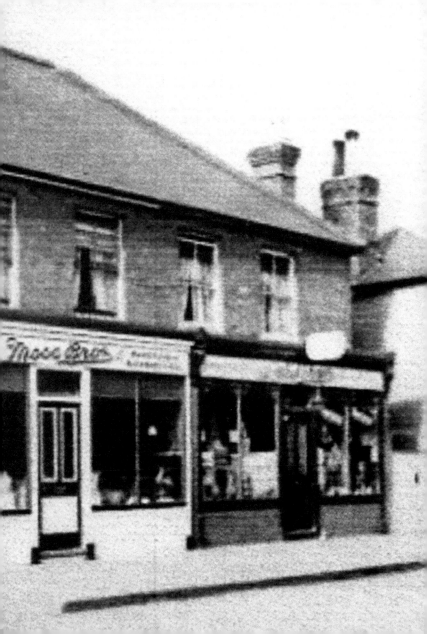

22. HIGH ROAD

Another view of the High Road with a number of old buildings and shops. Once again it is hard to find any of the old buildings in the High Road that have survived until today.

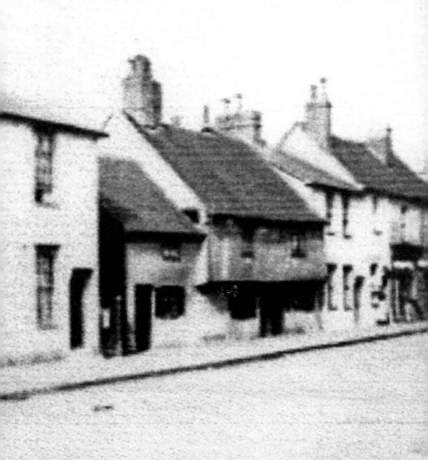

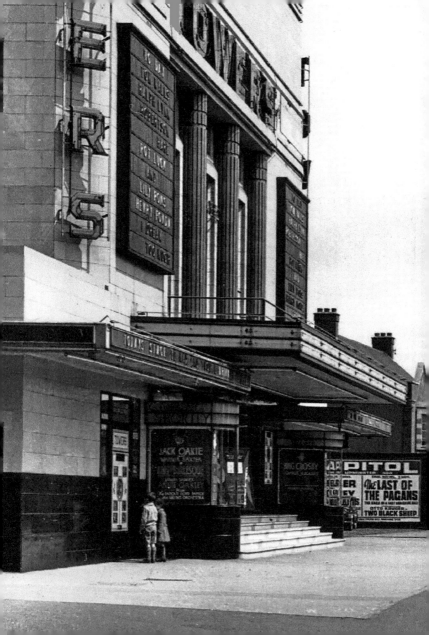

23. THE TOWER CINEMA

The Tower Cinema was named after the old Grey Towers House that stood nearby. For many years it was used as a bingo hall and the Tower sign had been covered up, though it was rediscovered recently. Unfortunately the bingo hall has now closed and the building is being demolished despite local opposition to build a retail outlet.

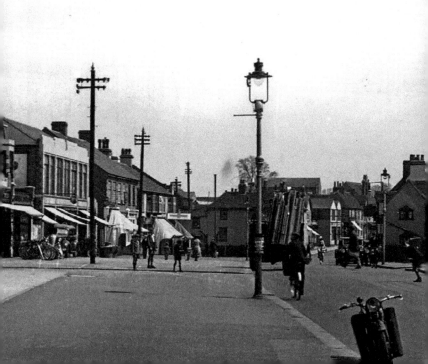

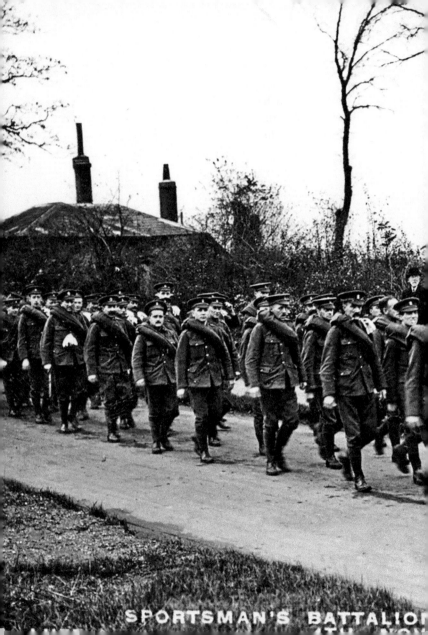

SPORTSMAN'S BATTALION

24. ST LEONARDS CHILDREN'S HOME

The image shows the Sportsman's Battalion arriving in Hornchurch in November 1914. The battalion were led into the camp by the band of the Hornchurch Cottage homes. This was a children's home that stood across the road a little further west than Grey Towers. There was an element of scandal about the home before it closed. The buildings survive, including the school, as a private housing estate.

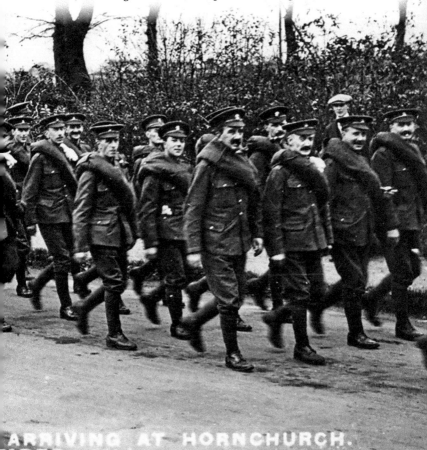

ARRIVING AT HORNCHURCH.

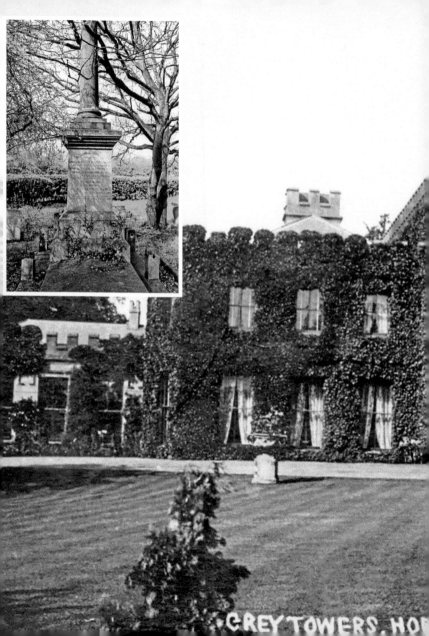

GREY TOWERS. HOR

25. GREY TOWERS HOUSE

Grey Towers House was built by Colonel Holmes and was very similar in design to his previous home, Harwood Hall, which still survives in Corbett's Tey. Grey Towers was built on land owned by Holmes' father-in-law, who owned the nearby Langton's estate. The house was demolished between the wars. The inset shows Colonel Holmes' grave in the churchyard.

CHURCH.

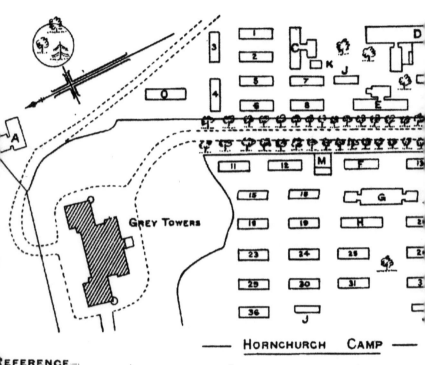

HORNCHURCH CAMP

REFERENCE —

1 & 2 BARRACK HUTS SERJEANTS 26 BEDS EACH. E. CANTEEN.
3 TO 37 BARRACK HUTS 30 BEDS EACH. F. STORE.
A. HOSPITAL. C. SERJEANTS MESS G. COOK HOUSE.
B. GUARD ROOM. D. REGIMENTAL INSTITUTE. H. DRYING ROOM.
O. OFFICES. P. CANTEEN STORE.

STRACHA

26. GREY TOWERS CAMP

During the First World War, Grey Towers became an army camp and the grounds were filled with wooden huts for the men to live in. The house itself became the officers' quarters. The map shows the layout of the camp, which was described as a modern camp despite the fact that the accommodation had no showers.

BLUTION SHEDS, 4.
ABLUTION SHED; SERJEANTS, I.
POWER STATION.
COAL SHED. 22 Mle. LATRINES.

& WEEKES, Engineers, S.W.

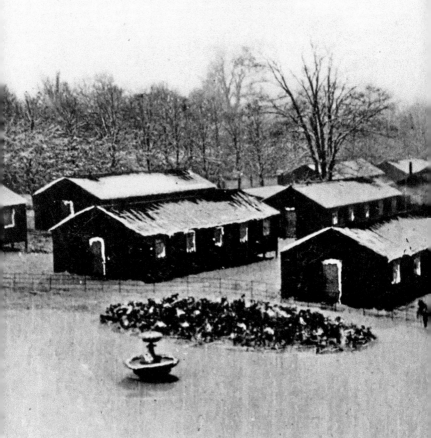

The Camp under Snow.

27. GREY TOWERS CAMP

The image shows the camp under snow and shows how difficult it must have been for the men. The huts did have heaters but were in fact no more than large sheds; living in them cannot have been very pleasant, although no doubt things got worse for them once they arrived in France.

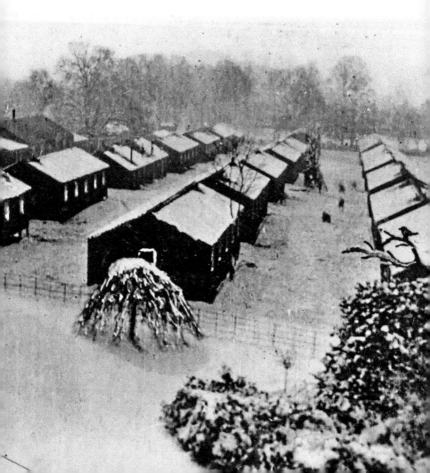

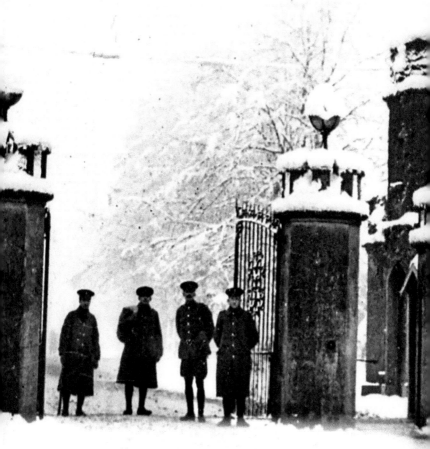

28. THE CAMP GATES

The photograph shows the gates into Grey Towers Camp. The gatehouse, or lodge, stood on the corner of what is now Grey Towers Avenue and survived much longer than the house did. There was obviously less concern about secrecy during the First World War as the sign to the right of the image here shows.

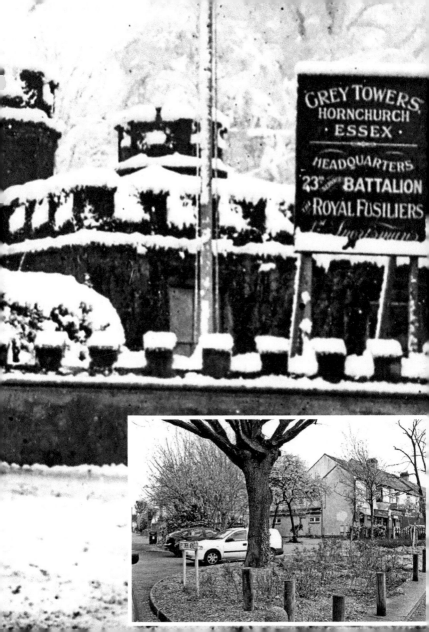

GREY TOWERS
HORNCHURCH
· ESSEX ·

HEADQUARTERS
23rd BATTALION
ROYAL FUSILIERS
1st Sportsmans

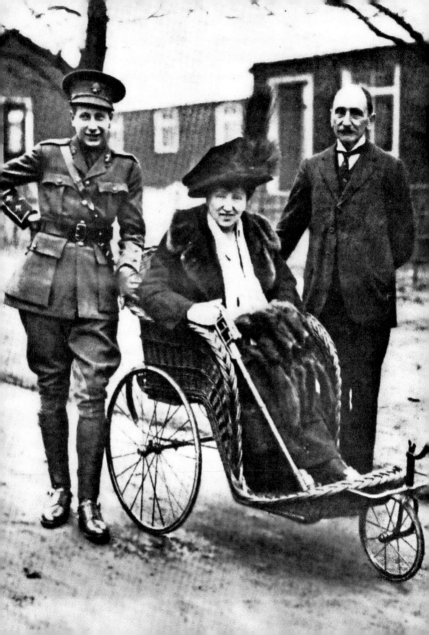

29. THE FOUNDERS OF THE BATTALION

Many army units during the First World War were privately raised, such as the pals battalions. The Sportsman's Battalion were no different and the founders visited Hornchurch. They were Mr and Mrs Cunliffe Owen. Their son was an officer in the battalion, which was also quite common in privately raised units.

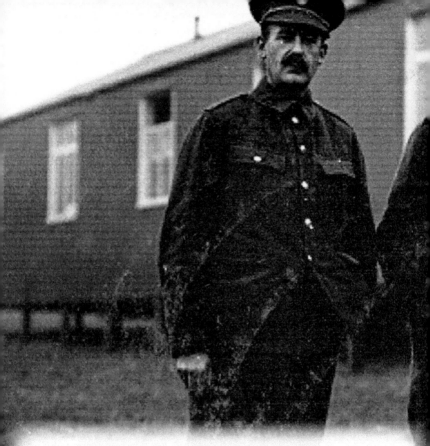

30. THE MEN OF THE BATTALION

Here are three named members of the Sportsman's Battalion. They were (left to right) E. G. Hayes, J. W. Hitch and Sandham. One of the huts at Grey Towers is visible in the background. Other members can be seen stood at the door watching, though photographs of the battalion were quite common due, no doubt, to their many well-known members.

"E. G. Hayes, J.W. H

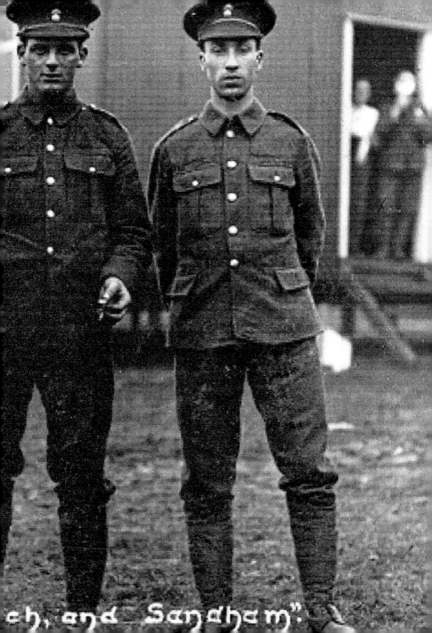

ch, and Sandham".

31. THE SPORTSMAN'S BID FAREWELL

The Sportsman's Battalion eventually left Hornchurch and believed that they were finally on their way to France. Here they can be seen marching through the town as they left. In fact they were moved to another camp – Clipstone Camp – in the north for further training.

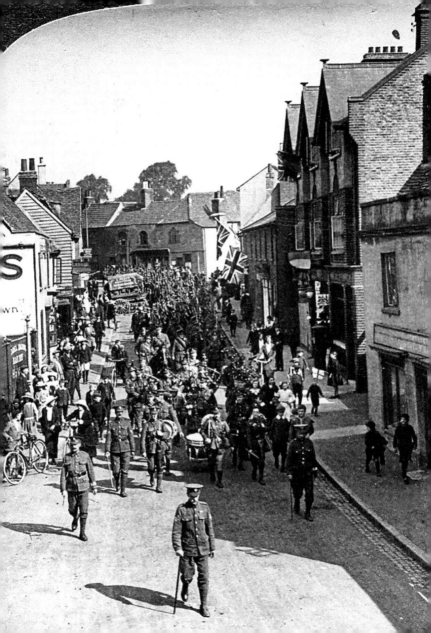

32. HARROW HILL

Harrow Hill is just to the east of the old Grey Towers House. The Harrow Pub is situated a little further east but the hill has not changed as much as the rest of Hornchurch with little building on either side of it – allotments are on one side and Harrow Lodge Park is on the other.

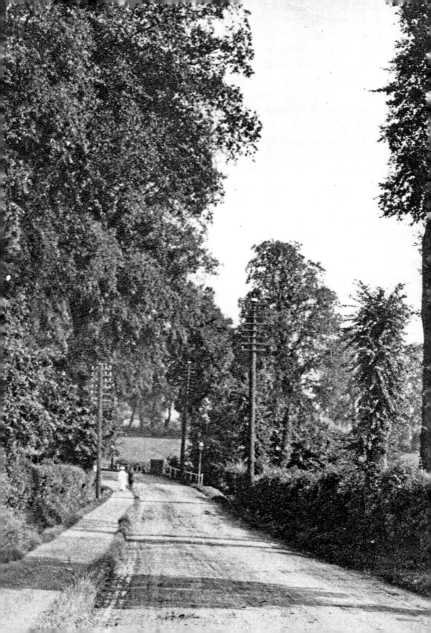

33. THE QUEEN'S THEATRE

The original Queen's Theatre stood in Station Lane, as can be seen in the photograph. It opened in 1948 after the local council bought a derelict cinema and turned it into the theatre. It was replaced when the present theatre was built in Billet Lane in 1975.

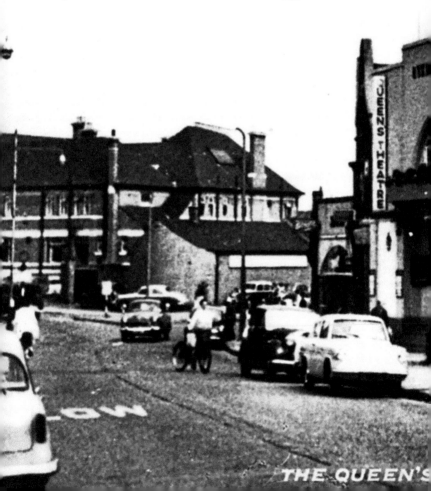

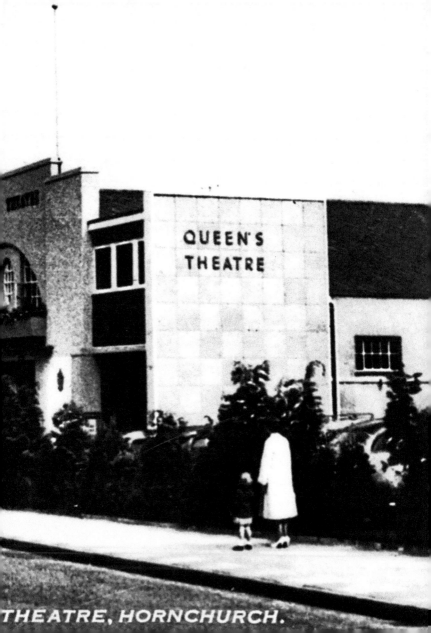

QUEEN'S
THEATRE

THEATRE, HORNCHURCH.

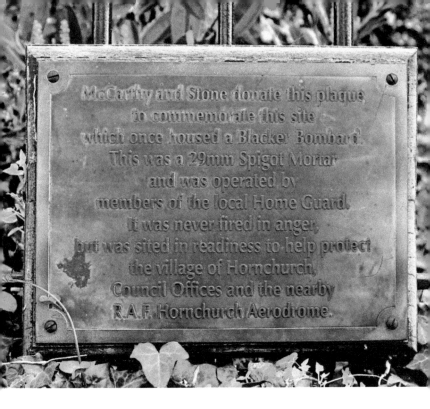

McCarthy and Stone donate this plaque
to commemorate this site
which once housed a Blacker Bombard.
This was a 29mm Spigot Mortar
and was operated by
members of the local Home Guard.
It was never fired in anger,
but was sited in readiness to help protect
the village of Hornchurch,
Council Offices and the nearby
R.A.F. Hornchurch Aerodrome.

34. HOME GUARD

In addition to the army bases during the First World War there was also an airfield in Hornchurch. This went on to be one of the bases used during the Battle of Britain in the Second World War. The airfield was partly protected by the Home Guard. One of their defensive positions was in Station Lane, where a Spigot Mortar was positioned – a favourite weapon of the Home Guard and commemorated by the plaque on the fence by the bus stop.

NATIONAL MEMORIAL
TO
JOHN CORNWELL V.C.

BOY (1ST CLASS) Nº J 42563
H.M.S. CHESTER.

DIED OF WOUNDS.

BATTLE OF JUTLAND

MAY 31 1916.

35. JACK CORNWELL

John Travers Cornwell, also known as Jack, joined the Royal Navy in 1915 at the age of fifteen. He was a member of the crew of HMS *Chester* during the Battle of Jutland, and despite everyone around him being killed, he stayed at his post. He died in 1916 of his wounds and was awarded the Victoria Cross. There is a memorial plaque on the gate of these cottages. The plaque was stolen a few years ago but was later replaced.

Suttons G

36. SUTTON'S GARDENS

Sutton's Gardens is close to the station, which made Hornchurch a popular place to live for commuters. The population grew between the wars when many of the houses in this area were built. When the Second World War began the area around Sutton's Gardens was a dangerous place to live as RAF Hornchurch along the road was an important target for German bombers.

rdeas, Hornchurch.

37. HORNCHURCH STATION

The Sportsman's Battalion often marched to Hornchurch station, where they would take a train to other parts of Essex to undergo trench-digging exercises. There do not seem to be any houses in the background at the time that this photo was taken.

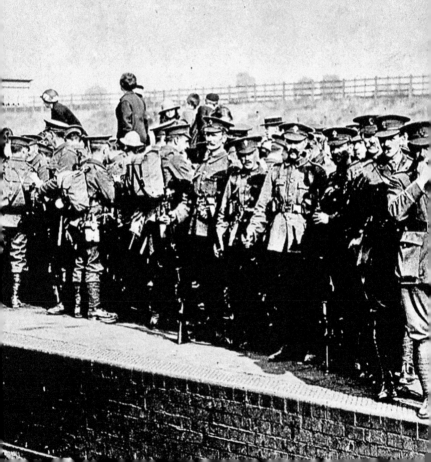

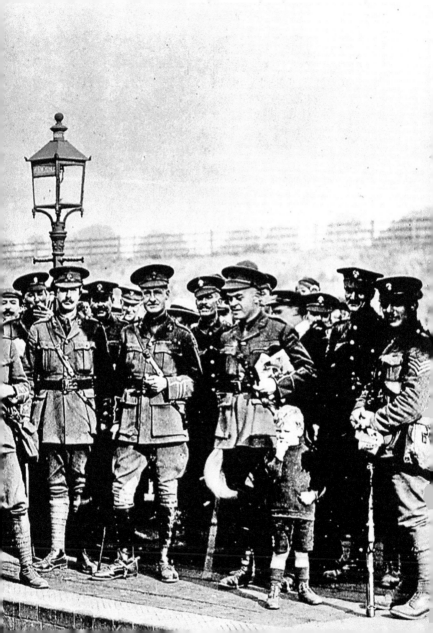

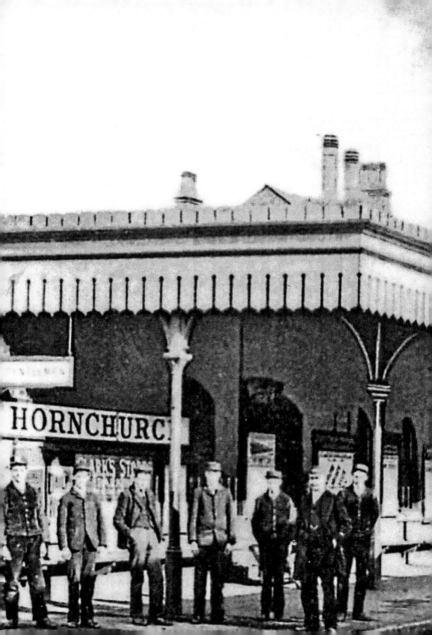

38. HORNCHURCH STATION

Hornchurch station was originally built in 1885 by the London, Tilbury & Southend Railway as part of a direct line from Fenchurch Street to Southend, missing Tilbury. It was rebuilt in 1932 by the London, Midland & Scottish Railway when two more platforms were added for the district line extension from Barking to Upminster.

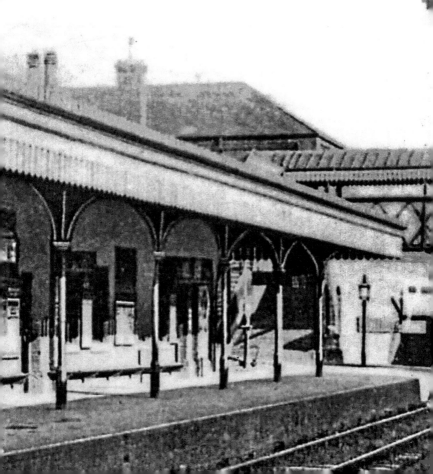

39. A HORNCHURCH HOME

In the days before the First World War a number of the residents of Hornchurch were quite well off. The address of this house was simply 'Elmhurst' as a name seems to have been enough of an address then. Perhaps the house still exists, although it may now have a door number instead of the name.

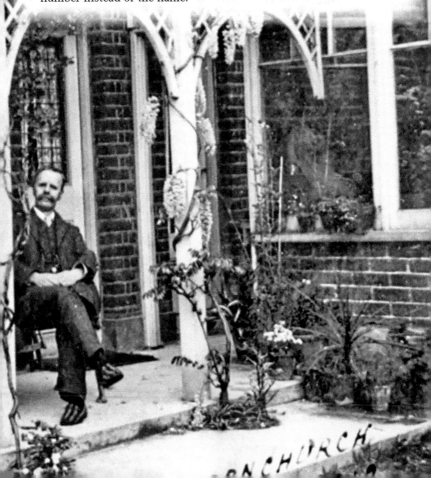

Station Rd. Hornchurch H. Luf

40. STATION LANE

This image of Station Lane shows how rural the area was in the past. I'm not sure of the date of this image but as the name Station Lane exists, it was obviously after the station was built.

Hornchurch. Essex.

Havering LONDON BOROUGH

HORNCHURCH
COUNTRY PARK

Site of the former
RAF Station Hornchurch

INGREBOURNE
VALLEY

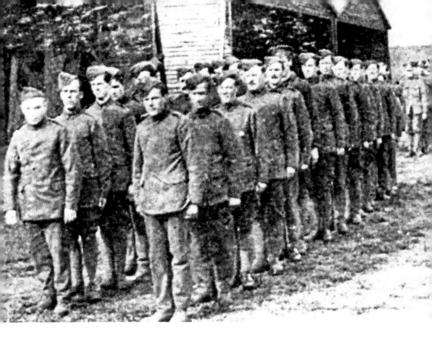

41. SUTTON'S FARM AIRFIELD

Station Lane led into Sutton's Lane and on to the airfield. It was seen as a temporary camp at first with hangers made from canvas and wood, as can be seen from the image. Many of the men based there lived in tents. It was very different from other army camps, such as Grey Towers just up the road.

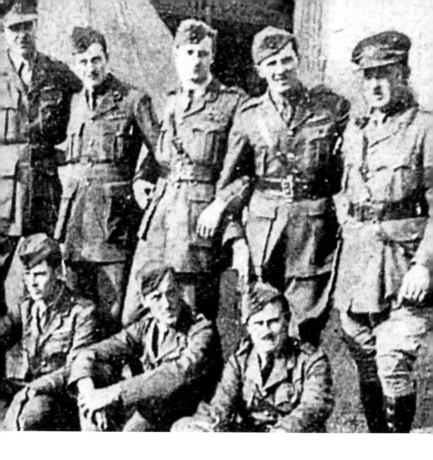

42. SUTTON'S FARM AIRFIELD

The airfield in Hornchurch became very famous after a pilot based there shot down a Zeppelin. Lieutenant Leefe Robinson became an overnight celebrity after he was the first man to shoot down a Zeppelin over land. He was awarded the Victoria Cross and graced the front of newspapers and numerous postcards. The image shows the officers at the airfield.

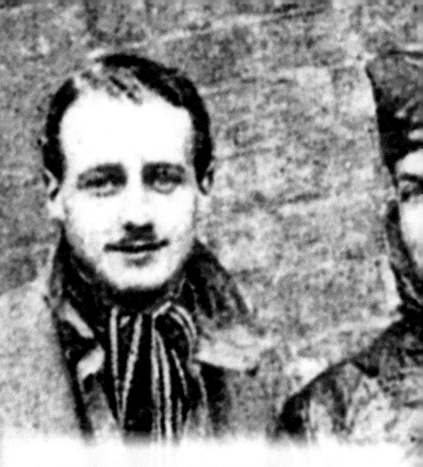

43. SUTTON'S FARM AIRFIELD

Although Sutton's Farm became well known after Leffe Robinson shot down a Zeppelin, it was in the news again when two other airmen from the airfield repeated Robinson's feat and shot down Zeppelins of their own, though they never achieved the fame that Robinson did. The image shows the three men who shot down the Zeppelins.

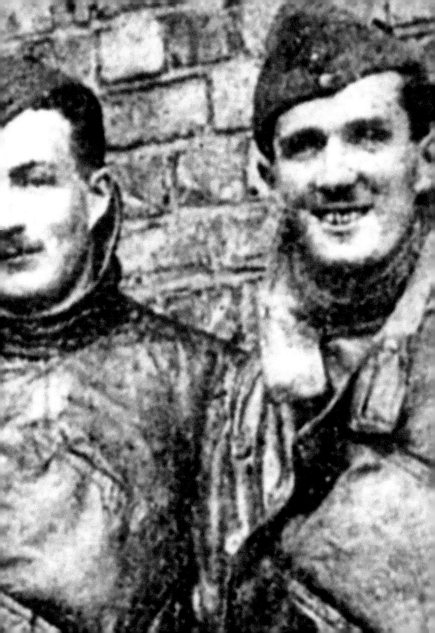

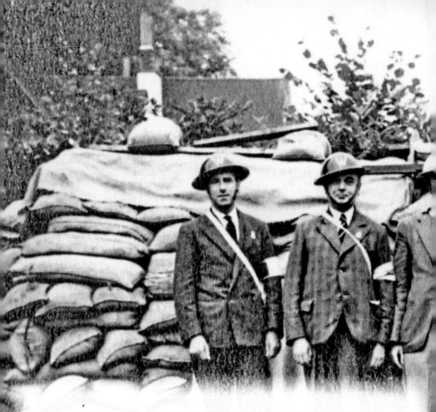

44. RAF HORNCHURCH

Although Sutton's Lane Airfield closed after the end of the First World War, it reopened again as RAF Hornchurch. It was to play a major part in the Battle of Britain and its memory lingers on despite the fact that it closed in the 1960s. The housing estate that now covers the old airfield has streets named after pilots and items connected to the airfield. The local school is named after the inventor of the Spitfire. The image shows a group of ARP wardens. Hornchurch suffered heavy bombing due to the airfield being located there.

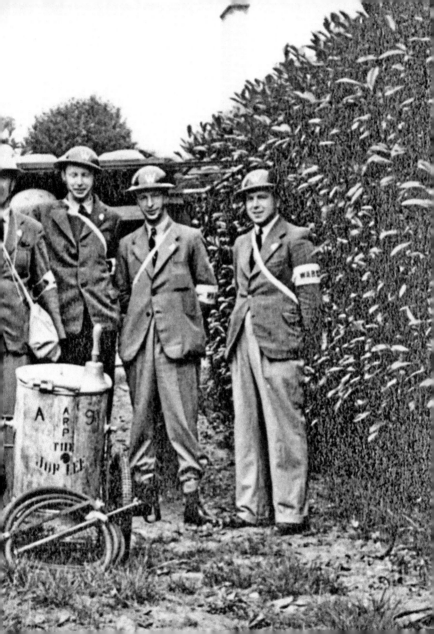

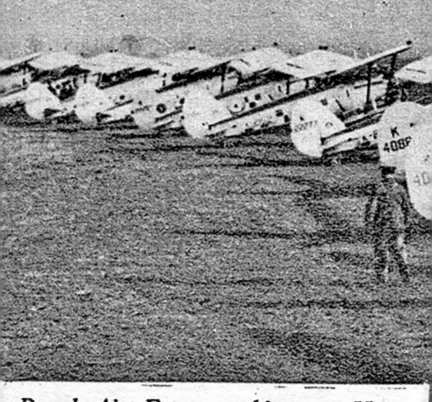

Royal Air Force machines at Hornchurch ready to defend London during the mimic air war

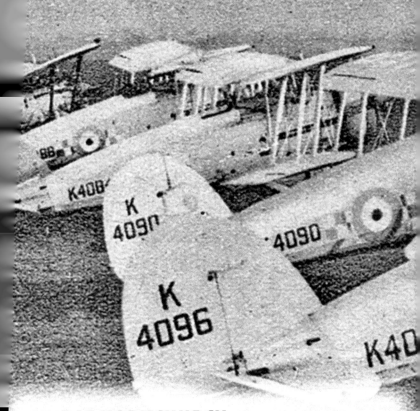

45. RAF HORNCHURCH

Here is an image of early aircraft at Hornchurch during the early part of the war. It is often said that Britain was not ready for the war when it came and the far from modern aircraft at the base seem to bear this out.